Words *of* Wisdom

Lama Surya Das

koa books

Koa Books
P.O. Box 822
Kihei, Hawai'i 96753
www.koabooks.com

Printed in the United States of America
Koa Books are distributed to the trade by SCB Distributors

Cataloging-in-Publication Data

Surya Das, Lama, 1950–
Words of wisdom / Lama Surya Das. — Kihei, Hawai'i :
Koa Books, ©2008.
 p. ; cm.
 ISBN: 978-0-9773338-7-5
 1. Conduct of life—Quotations, maxims, etc. 2. Wisdom—
Quotations, maxims, etc. 3. Spiritual life—Buddhism. I. Title.

BQ5660 .S89 2008
294.3/444—dc22 0806

1 2 3 4 5 6 7 8 9 / 12 11 10 09 08

INTRODUCTION

I was going to call this book *SOS: Sayings of Surya,* or possibly *Secrets from Tibetan Fortune Cookies,* or even *Duckbilled Platitudes*—but cooler heads prevailed, and came up with *WOW (Words of Wisdom).*

Perhaps you have some sudden illuminations to add. Don't sell yourself short. When you feel hopeless in the presence of huge challenges, try to be an optimistic realist.

Together we can be beautiful and edify the world!

Lama Serious Das
Dzogchen Center
Cambridge, Massachusetts
March 2008

Don't just seek others' light.
Cultivate your own natural resources.

What we seek, we *are*.

Why exhaust yourself on tiptoes?
Be at ease on your own two feet.

One moment of total awareness
is one moment of freedom
and enlightenment.

Killing time is deadening ourselves.

The secret is Optimal Presence.

Find a way to do it and be it.

Singing is believing.

Why forgive and forget?
Better to forgive and remember.

Learn the lessons.

You can't control the wind,
but you can learn to sail.

It's not what happens to us but what we make of it that makes all the difference.

Listen to yourself.
Know yourself.

Love without truth is blind.
Truth without love is deadly.

Wisdom is as wisdom does.

Life is breath.
Breath is spirit.
Spirit is joy.

I'm enlightened enough for now.

Nature is our guide.
We can study it daily.

Pray for what you have.
Give thanks, and all prayers
will be answered.

I hear America singing,
"Don't just gimme that ole time religion…"

Don't just seek a secure harbor.
Build an oceangoing vessel.

Everything is subjective.

Buddha's not pretending.

Deconstruct the hut that ego built, and explore the palace of blissful awareness.

Wisdom heals all ills.

Surrender to What Is.

Miracles happen.

Love is far greater
than our likes and dislikes.

The heart is an organ of perception.

"What is reality? What is the infinite?,"
we ask while looking at the sky
through a straw.

Thank God for Buddhism.

Practice being there while getting there.

Every step is the Great Way.

Seekers must one day become finders.
Stop procrastinating.

Meditate as fast as you can.

 Laughter is the best medication.

Why be a wooden Buddha?
Spirit is ecstatic, not static.

We need a spiritual life,
not just special experiences.

True spirituality doesn't take us
away from the world.
It connects us even more deeply.

Where is God?

Where are we?

You may feel far from It,
but rest assured It is never far from you.

Enlightenment is not an end, but a beginning. Infuse it into every nook and cranny of your life.

Don't mistake schooling for education.

Reality is not all it's cracked up to be.

No one knows everything.
No one knows nothing.
Everyone has a piece of the puzzle.

When you don't know what to do,
try doing nothing.

Something will come up.

See things as they are, not as they ain't.

The sunlight of awareness
clarifies everything.

Repeating habits is a bad habit.

The Mouse Principle of Life Processing—
Let go or get dragged.

Buddhas have more fun.

Change is the law,
But who is ready, willing,
and able to really change?

Letting go means
letting come and go, letting be.

Letting go means
opening to the wisdom of allowing.

This is nonattachment.

Grasping fleeting things too tightly,
gives us rope burn.

There is nirvanic peace in things
just as they are.

Contentment is true wealth.

Rest in the natural state—
or whatever state you're in.

Seeing through and being seen through,
neither too tight nor too loose.

Be *transrealescent*.

No rearview mirror driving.
Straight forward.

Do you know where your mind is today?
The mind can be a terrible thing to watch.

Nothing to do but remain in the View.

Meditation is a way of being,
not just one more kind of doing.

Life is precious.
Handle with prayer.

There is transformative magic
in accepting things as they are.

Gratitude is my favorite prayer.

In life, as in golf,
your grip determines how you play.

That which we call "I" is just impermanent,
ownerless karma rolling along.

Don't take it personally.

Right here, just as you are—
this is the moment,
the timeless time beyond time.

Don't miss it!

Love isn't outside.
Love is an inside job,
found through loving.

Rebirth is like grade school.
If you don't get it, you'll be held back
until you do.

Forgiveness is heart healthy.

One good heart deserves another.

Wisdom and compassion are the wings
that make our spirits soar.

When we say Yes to life, meeting whatever
befalls us with authentic presence,
we grow happier, deeper, wiser,
more loving and caring.

Truth telling is a rigorous spiritual practice.

Mistakes and imperfections—
the cracks where light gets in.

Adversity tempers the spirit.
This is gaining through loss.

The Pearl Principle—
No inner irritation, no pearl.

To know an anchor's strength,
you need to test it in a storm.

Everything is fuel for
the bonfire of awareness.

Use the Teflon side of your mind,
not just the Velcro side.

Travel light, and you'll soon arrive.

Enlighten up.
Life is too important to take too seriously.

Look into others, and see yourself.

We are all Buddhas.
We only need to recognize ourselves.

See the Light in everyone.

Remember the American mantra:
"Life is like a dream, a fantasy, a sitcom."

Resistance is another form of clinging.

Try being a Type B—
for Buddha—personality.

Natural body is Buddha's body,
Natural breath is awakened breath
and energy,
Natural mind is liberated mind.
Naturalness is the Way.

The real work in life is doing
what needs to be done, no more
and no less.

Don't mistake movement for meaning.

Who knows the use of uselessness?

Change is the Law.
Impermanence rules.

Enjoy the delectable essence of Presencing.

It's not about getting from here to there.
It's about getting from here to *here*.

Don't wait to find solid ground.
Dance in emptiness.

Sail freely on the vast sea.
Ride the waves and enjoy the journey!

Don't let your mind bother you
and don't bother your mind.

Buddha said, "Seize the Moment!"
(Or was that Abbie Hoffman?)

Why struggle and trudge along,
schlepping your way to enlightenment?
Try dancing and singing,
soaring and swooping.

Skygazing meditation:
open eyes,
open posture,
open heart,
open breath,
open mind.

Breathe, focus, smile.
Let go and let be.

If Buddha were alive today, he'd add
a few extra innings to the Noble Path,
like Good Humor, Healthy Living,
and Relationship Yoga.

Enlightenment is not like getting to heaven.
It's more like the sky falling on your head.

We can learn from both the wise
and the foolish.

Sometimes it's hard to tell the difference.

Each time you step up to the plate,
swing like Babe Ruth,
without thinking about results.

Practice nondoing, and see how
everything falls into place.
This is the secret of natural meditation.

Awareness practice helps us become
more transparent to ourselves.

When you're clear, everything is clear.

It's so close, we overlook it.

Abide in the true heartland.
No need to look anywhere else.

Turn your spiritual searchlight inward.

Self-inquiry is the mirror that sees
the back of its own head.

Turn around quickly and see the seer.

Experience the experiencer, and be free.

Meditation is good daily hygiene,
like mental floss.

Transforming ourselves,
we transform the world.

Healing ourselves,
we heal the world.

Knowing ourselves,
we know the world.

Everyone is a little crazy, especially me.
Remembering this helps us lighten up.

Don't fall off your Buddha seat
by leaning into the future
or reclining into the past.

You must be present to win.

Let go of your enlightenment project
and let grace descend.

Who do you think is doing it, anyway?

Dive straightforward
into the deep waves of life.
Don't just tiptoe in the shallows.

Why be a wallflower in life's ballroom?
Spread your wings and dance like a Dervish.

Take it flow.

Don't look for Mr. or Ms. Right.
Right yourself, and the whole world is right.

If you want to be happy,
make someone happy.

If you want to be needed,
find a need and fill it.

If you want to be good, be good.

Insight can't be taught,
but it can be caught—
when you catch on.

Natural meditation is like basketball
with a hoop as wide as the world.

You can't miss!

Nature is our treasure.
Reverence comes naturally.

We are not just human beings
trying to live more spiritually,
but spiritual beings learning to live
in space and time.

Bowing is an elegant yogic training
for body, mind, and energy.

Every bow says, Slow down.

Drop egotism, and surrender to
your innate spiritual nature.

When no one bows to nothing,
everything is included.

Let's be engaged Buddhists,
not enraged Buddhists.

Fighting for peace is
a contradiction in terms.

Many are called, but few awaken.

Breathe in the fresh air
and connect with the Holy Now.

Create an oasis of inner harmony
and peace.

It's now or never, as always.

Intellect is a good servant
but a poor master.

We can't just believe whatever we think.
We think, therefore, we err.

Buddhahood is in the palm of your hand.

Natural mind is Buddha Mind.

Love and accept yourself,
and the world will embrace you.

Live from your gut—
front-row center.

The best seat in town.

Let the Buddha breathe through you.

You are far more Buddha-full
than you think.

People crossing.

Slow down, yield,

Merge.

Mind is mightier than the sword
Authentic presence is everything
Loving actions fulfill life's meaning
We're all in the same boat
We all rise and fall, sink or swim, together
Let's uplift each other
And drive the shadows from our faces
Illumining all

DZOGCHEN CENTER
BUDDHISM FOR THE **WEST**

Dzogchen Center, founded by Lama Surya Das, offers Buddhist contemplative practices to help alleviate suffering and create a civilization based on wisdom and compassionate action.

Please visit dzogchen.org for information about teaching and retreat schedules and local meditation groups.

PO Box 340459
Austin, Texas 78734
www.dzogchen.org

koa books

Koa Books publishes works on personal and social transformation, and native cultures.

Please visit koabooks.com for a list of recent and forthcoming titles.

PO Box 822
Kihei, Hawai'i 96753
www.koabooks.com